3-D DOODLE

BOOK + KIT

by
Elizabeth Encarnacion

APPLESAUCE PRESS

Kennebunkport, Maine

13-Digit ISBN: 978-1-60433-095-3
10-Digit ISBN: 1-60433-095-3

This book may be ordered by mail from the publisher.
Please include $2.50 for postage and handling.
Please support your local bookseller first!

Books published by Cider Mill Press Book Publishers are available at special discounts for bulk purchases in the United States by corporations, institutions, and other organizations. For more information, please contact the publisher.

Cider Mill Press Book Publishers
"Where good books are ready for press"
12 Port Farm Road
Kennebunkport, Maine 04046

Visit us on the Web!
www.cidermillpress.com

Design by Alicia Freile, Tango Media
Typography: Antique Olive and Jacoby
All illustrations courtesy of Sherry Berger
Printed in China

1 2 3 4 5 6 7 8 9 0
First Edition

Table of Contents

Doodles 101

What Is a Doodle?

Unlike more formal drawings, a doodle is a rough sketch that is usually made while the artist is distracted or lost in thought. Doodles are often drawn on the corners of notepads, the margins of printed documents, or the cover of notebooks—anywhere there's a little space. Doodling can help entertain you when you're extremely bored by your surroundings. Students frequently draw cartoonish caricatures of teachers during class, while a businessperson might doodle geometric shapes on a piece of paper during a long phone call. Doodlers are often criticized for being inattentive, but scientific studies have proven that doodling may actually help improve your memory.

Doodles come in all shapes and sizes, and the types of doodles you draw may give clues about your personality. If you tend to doodle geometric shapes or patterns, you're probably a very organized, logical person who plans things out in detail. Drawing faces or flowers is often a sign that the artist is friendly and enjoys being around other people. Sketches of boats, airplanes, or cars might indicate that you need a vacation or love to travel. What do your doodles say about you?

Famous Doodlers

Throughout history, many great scholars and artists have doodled in the margins of their work. Leonardo da Vinci, the famous Renaissance artist who painted the Mona Lisa, was also a noted scientist and inventor. He regularly doodled in his notebook as a way of thinking more creatively. Many of his most famous inventions began as theoretical sketches in his journal. Poet John Keats and writer Ralph Waldo Emerson both reportedly doodled in their schoolbooks and on class assignments while attending college.

Many U.S. presidents have doodled on documents while they were in office. Franklin Delano Roosevelt, who served a record four terms as president from 1933 to 1945 and was an avid fisherman, escaped from the seriousness of the Great Depression and World War II by sketching boats and fish. President John F. Kennedy, who loved to sail, also frequently drew boats on his papers. As a young man, Ronald Reagan had considered becoming a cartoonist; his doodles were often well-drawn characters such as football players and cowboys.

The Science of 3-D

Humans have binocular vision. Basically, that means we have two eyes that are set about two inches apart from each other and help us determine distance and depth. Each of your eyes sees things from a slightly different angle, so they send two separate images to your brain. Your brain combines the two images and calculates how far away everything is to give you a complete, 3-D picture of the scene.

To test this, hold your finger about four inches in front of your face and focus on the bug doodle on this page. You should see two ghosted fingers, one on each side of the bug. These are the two images your eyes are sending to the brain. If you shut your left eye, you'll see that your right eye is seeing the finger on the left-hand side, and vice versa.

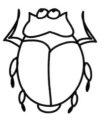

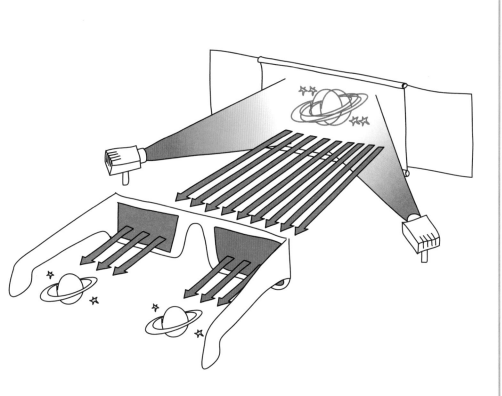

How Do 3-D Glasses Work?

Photographs, film, and doodles are all two-dimensional, meaning they are printed or projected onto a flat surface. Thus, the image each eye sends to your brain doesn't give the brain enough information to determine how deep different parts of the picture are. If the filmmaker or artist wants you to see their work in three dimensions, he or she will need to trick your brain into seeing depth where it doesn't really exist.

A 3-D movie is filmed through two different cameras that are about as far apart as a person's eyes. One camera has a red filter over the lens, while the other has a blue or cyan filter over the lens. Because

the cameras are about as far apart as a human's eyes, they are filming images that are skewed slightly and will give the brain clues about distance and depth. In the theater, one of the images is shifted slightly to one side so the colors remain separate and the images will float slightly above the screen.

The moviegoer watches the film through 3-D glasses that have one red lens and one blue or cyan lens. These lenses are color filters that allow a different image to reach each eye. The brain then combines those images and is fooled into thinking the pictures on the screen are three-dimensional.

3-D Doodles

Making 3-D doodles is a lot simpler than filming a 3-D movie. However, it still involves creating red and blue images that are essentially the same, but shifted slightly apart from

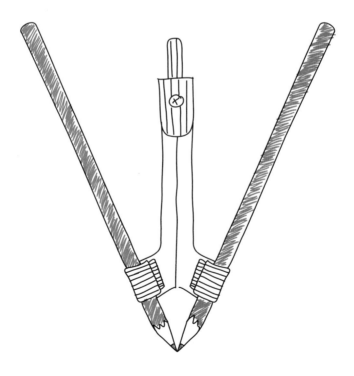

one another. The 3-D compass is a tool that helps you draw with red and blue pencils at the same time so you can make sure the two images are identical and the images are shifted slightly apart. The 3-D grid also uses red-blue 3-D technology, except it makes your drawing surface seem to move further away so your black ink doodles appear to float above the page.

Doodles aren't as detailed as photographs, so drawings made with the 3-D compass and grid need some extra help to look really amazing. This sketchbook includes tons of tips that will help you learn to make your doodles leap off the page and impress your friends. So, let's get started!

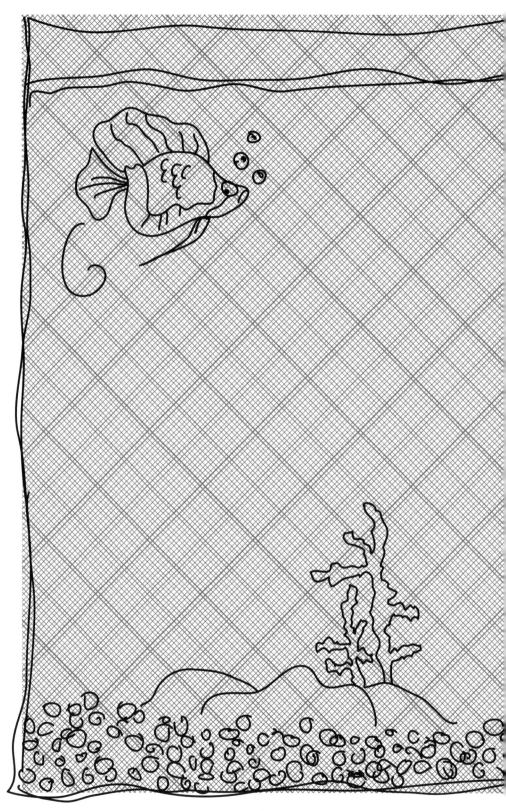

Go Fish

Use a black pen to fill this aquarium with more fish, some aquatic plants, and maybe even some sunken treasure or a deep-sea diver. Then, put on your 3-D glasses and watch the water come to life!

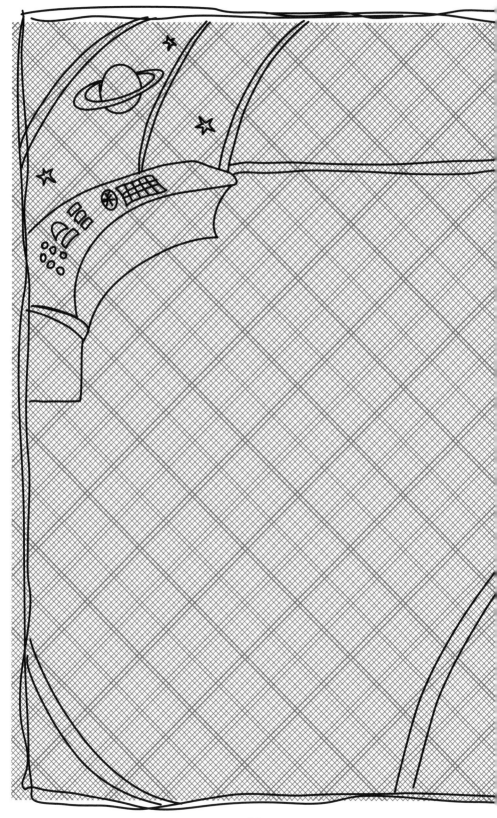

Out of This World

Design your own intergalactic spacecraft using a black pen and your creativity. The 3-D grid will create a floating effect that mimics the weightlessness in outer space.

Shape Up

Use traditional three-dimensional shapes on the 3-D grid to give your drawings even more depth. It's a snap to transform these simple shapes into amazing doodles like buildings and rocket ships with just a few extra details! What can you create with these cubes, pyramids, cylinders, and cones?

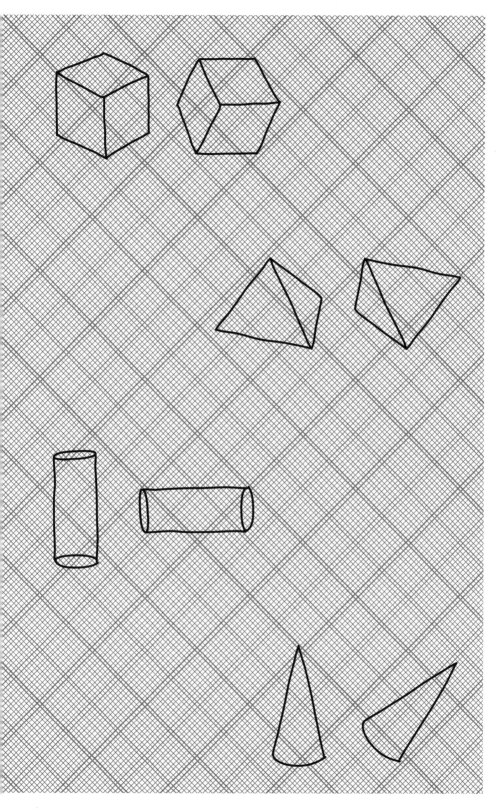

Word Play

Block letters already look three-dimensional, so they will really pop when drawn on the 3-D grid. Practice writing different letters below, then combine them to write words like your nickname, your favorite city, or your favorite sports team on the opposite page. You can also try connecting the block letters back to a single point with lines so the word looks like it is jumping off the page.

Tip:
Draw doodles around your 3-D block words to frame them.

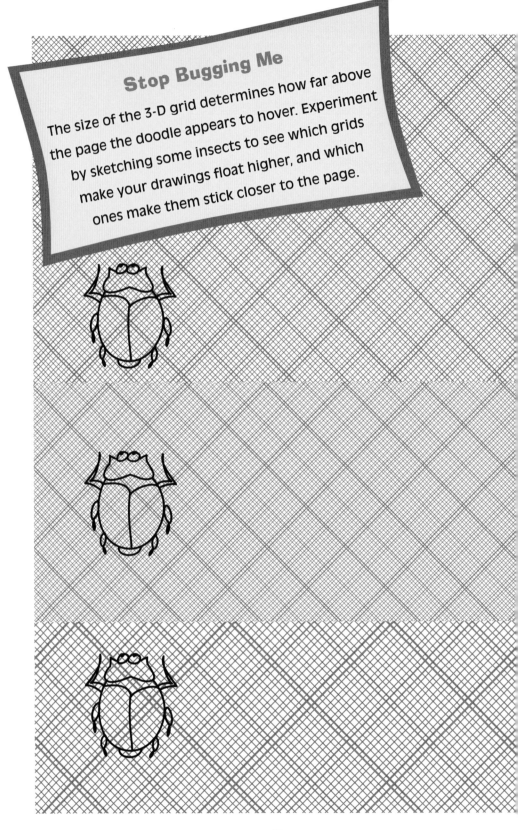

Stop Bugging Me

The size of the 3-D grid determines how far above the page the doodle appears to hover. Experiment by sketching some insects to see which grids make your drawings float higher, and which ones make them stick closer to the page.

Spaced Out

Fill in the expanse of outer space with more planets, stars, satellites, spacecraft, and maybe even an alien or two. Use the different grid sizes to give your finished scene extra depth.

Good Knight

Give this fire-breathing dragon a magnificent body. Then add a few of his mystical friends to back him up, and some fierce knights (or maybe even a brave warrior princess) to fight the beasts.

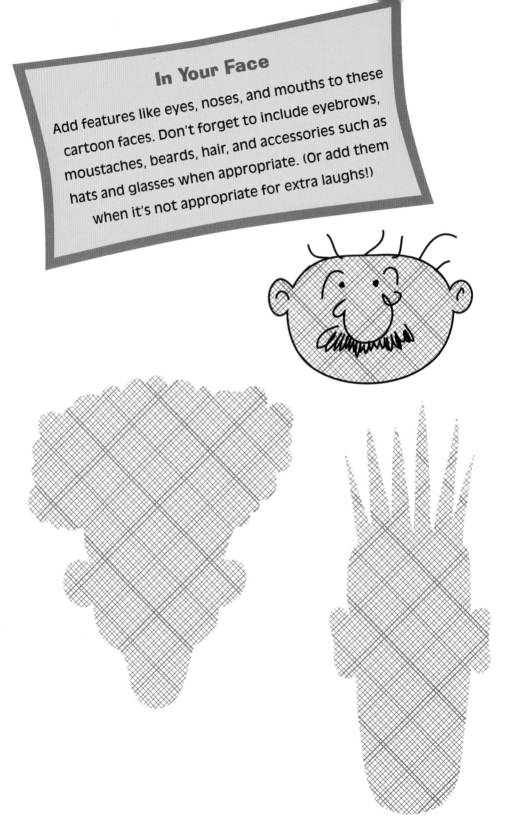

In Your Face

Add features like eyes, noses, and mouths to these cartoon faces. Don't forget to include eyebrows, moustaches, beards, hair, and accessories such as hats and glasses when appropriate. (Or add them when it's not appropriate for extra laughs!)

Tip:
Outline the 3-D grid shapes to maximize the impact of the stereo effect.

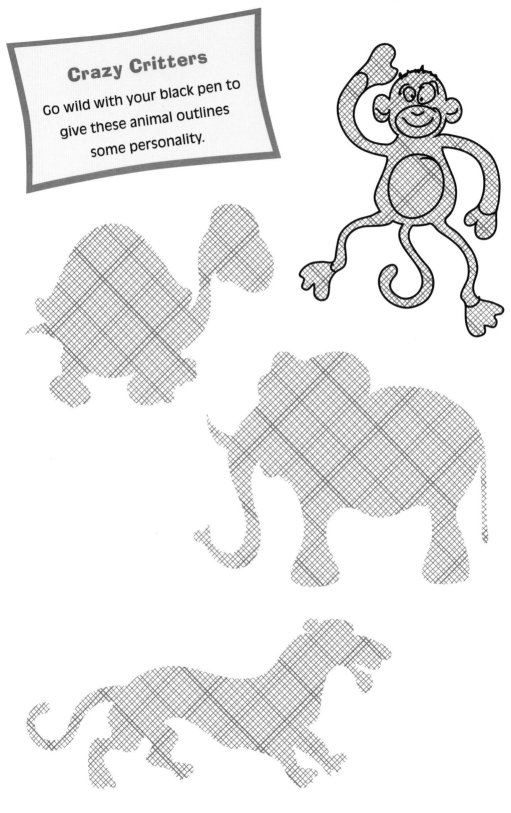

Crazy Critters

Go wild with your black pen to give these animal outlines some personality.

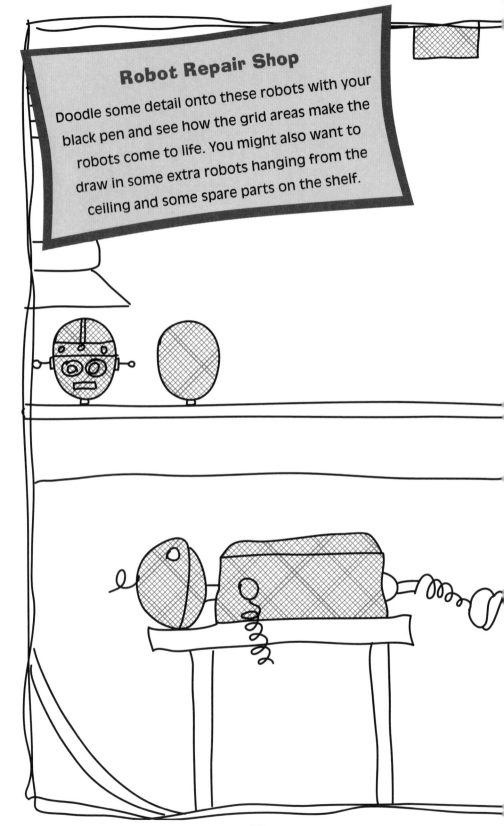

Robot Repair Shop

Doodle some detail onto these robots with your black pen and see how the grid areas make the robots come to life. You might also want to draw in some extra robots hanging from the ceiling and some spare parts on the shelf.

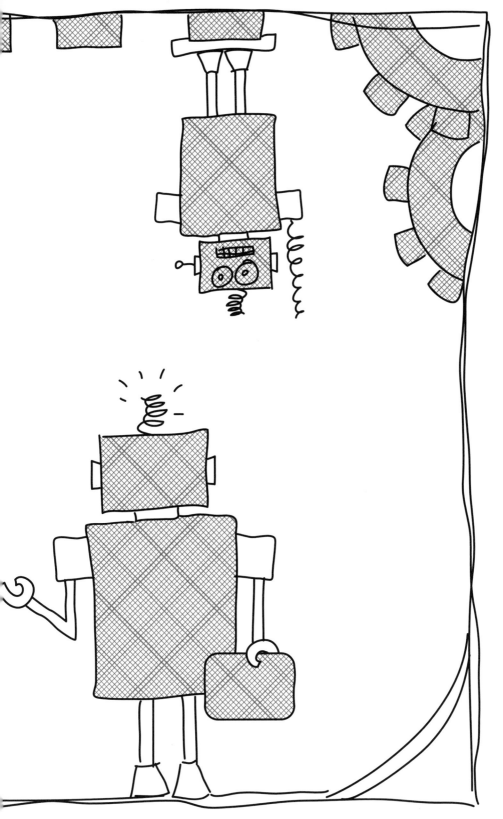

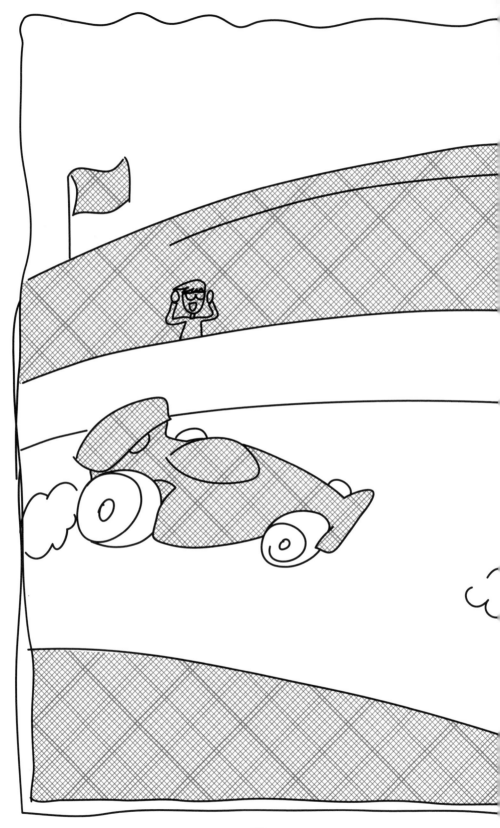

Off to the Races

Customize these racecars with flashy details on the grid sections. Add in the drivers, pit crew, and fans in the grandstand, and don't forget to finish off the checkered flag!

Drawing in Pairs

To create red-blue stereo images, adjust your 3-D compass until the two colored pencil tips are almost touching. Then, hold the middle part of the compass to draw your doodles, always keeping the blue pencil to the left of the red pencil as you move around your image.

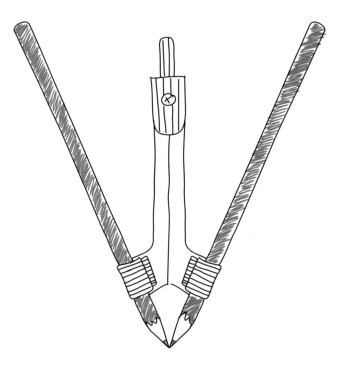

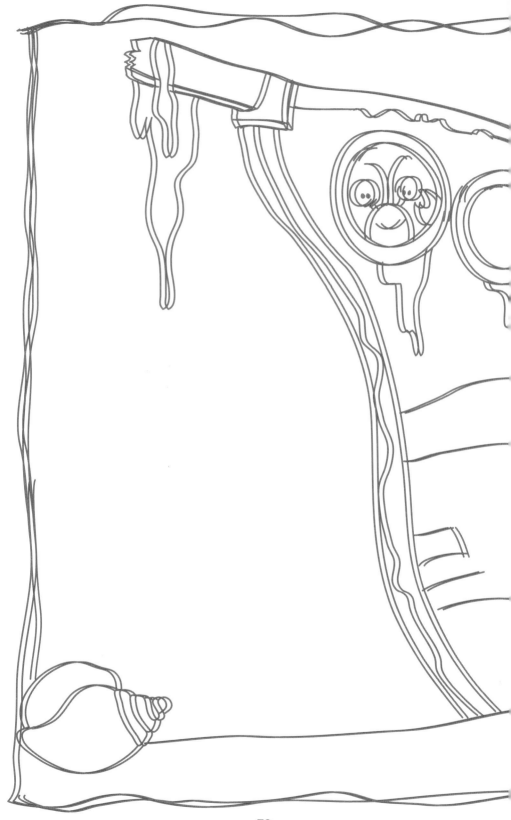

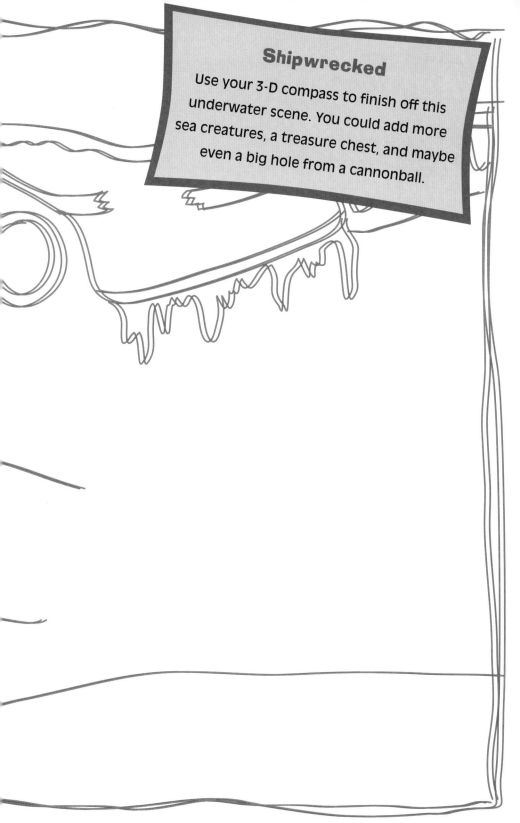

Shipwrecked

Use your 3-D compass to finish off this underwater scene. You could add more sea creatures, a treasure chest, and maybe even a big hole from a cannonball.

Let's Face It

Finish off these funny faces by drawing in their features—eyes, nose, mouth, facial hair, accessories—with the 3-D compass.

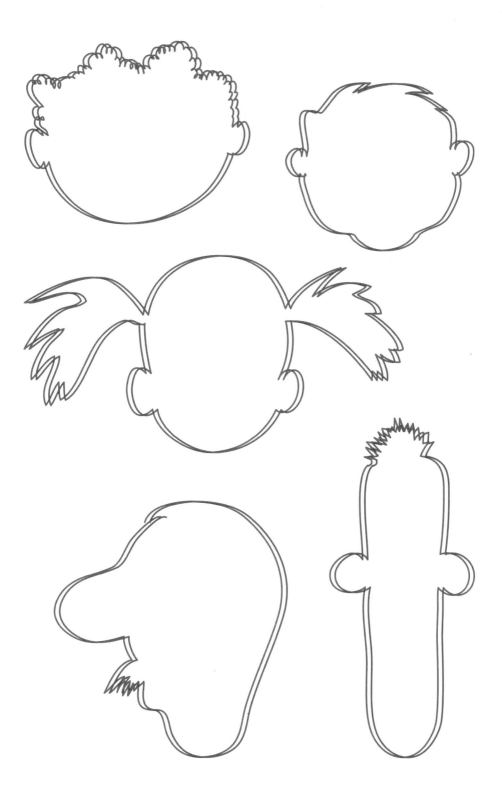

Under the Big Top

Use a combination of your 3-D compass and a black pen to give your drawings more depth. Give this strongman a 3-D barbell, add a trapeze artist in black, and draw a black serpent for the snake charmer. Then add in some circus performers of your own!

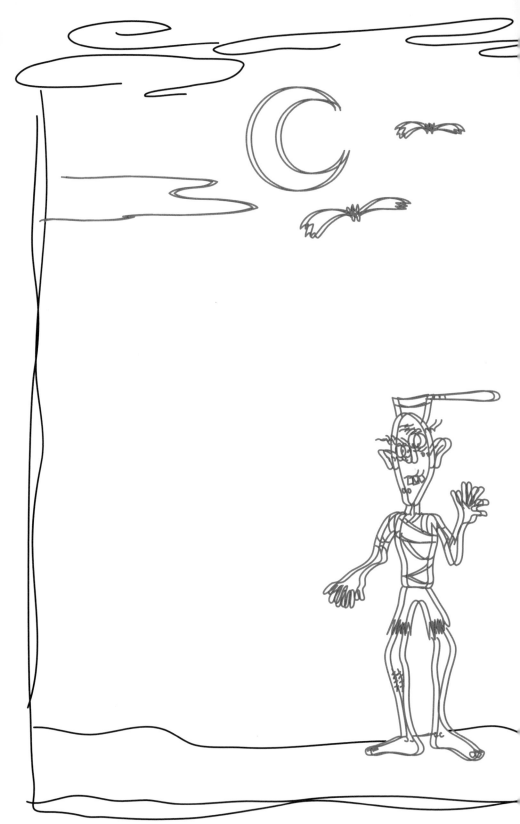

Night of the Living Dead

Use a combination of black lines and your 3-D compass to finish off this ghoulish doodle with some more movie monsters. The creepier the creatures, the better they will look in 3-D!

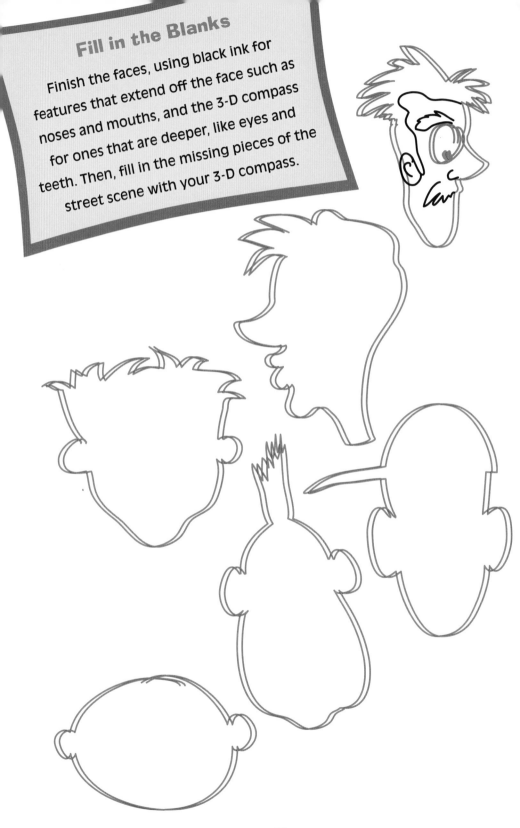

Fill in the Blanks

Finish the faces, using black ink for features that extend off the face such as noses and mouths, and the 3-D compass for ones that are deeper, like eyes and teeth. Then, fill in the missing pieces of the street scene with your 3-D compass.

Cookie Cutter

Fill in these black outlines with details using your 3-D compass.

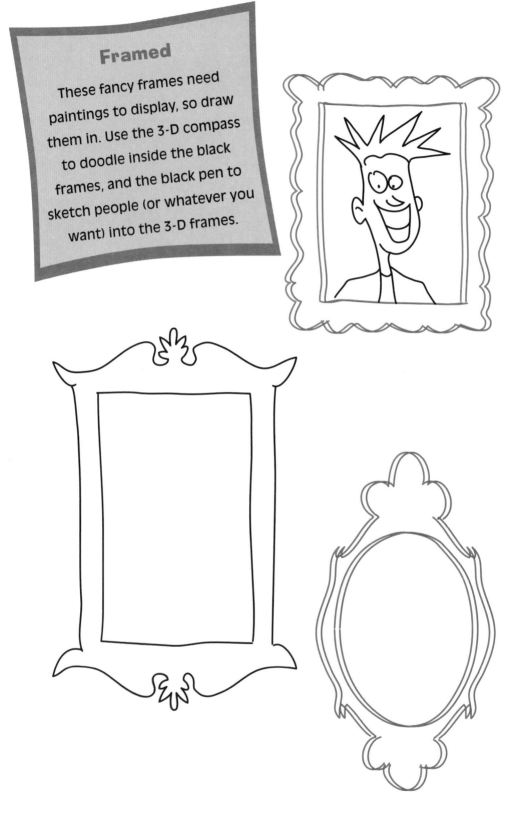

Framed

These fancy frames need paintings to display, so draw them in. Use the 3-D compass to doodle inside the black frames, and the black pen to sketch people (or whatever you want) into the 3-D frames.

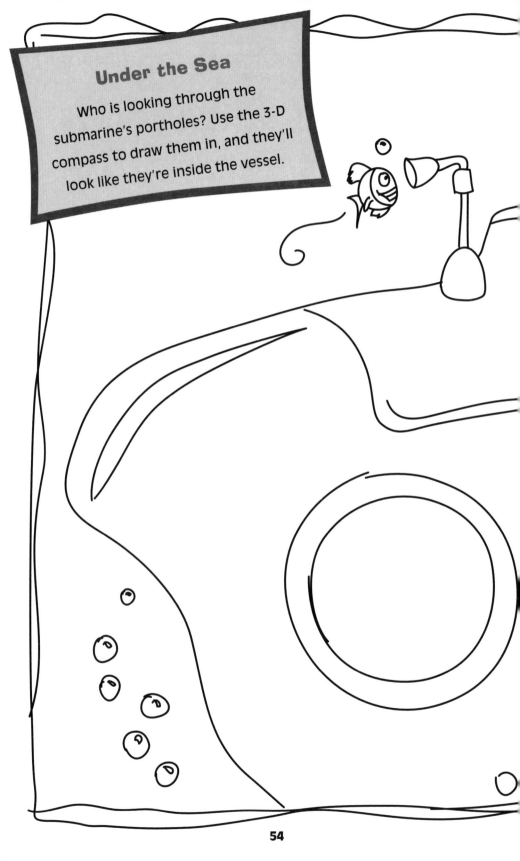

Under the Sea

Who is looking through the submarine's portholes? Use the 3-D compass to draw them in, and they'll look like they're inside the vessel.

Shapeshifting

Draw three-dimensional shapes like cubes and cylinders with the 3-D compass for a super-3-D look. Then add a few details to convert them into everyday objects.

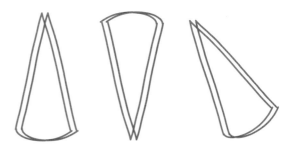

Building Blocks

Transform this simple city into a bustling metropolis by drawing buildings, vehicles, and other objects based on simple three-dimensional shapes.

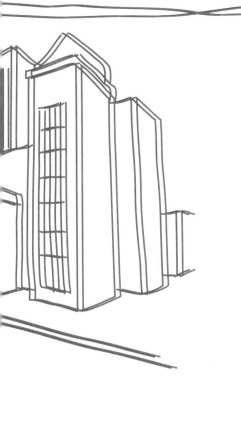

In Other Words

Give your block letters and words extra zing by writing them with your 3-D compass.

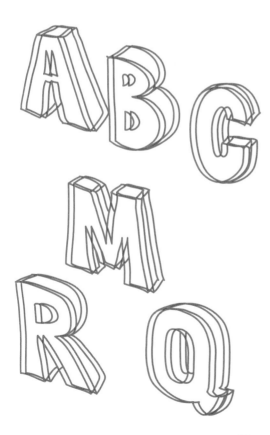

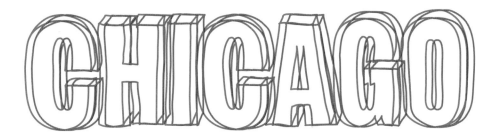

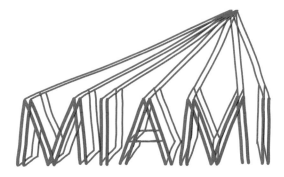

Sign of the Times

Whether you're designing a birthday banner or a family crest, use your 3-D compass to make the words and pictures come to life.

Mission to Mars

Use a combination of all the 3-D techniques you've practiced to make this space scene out of this world!

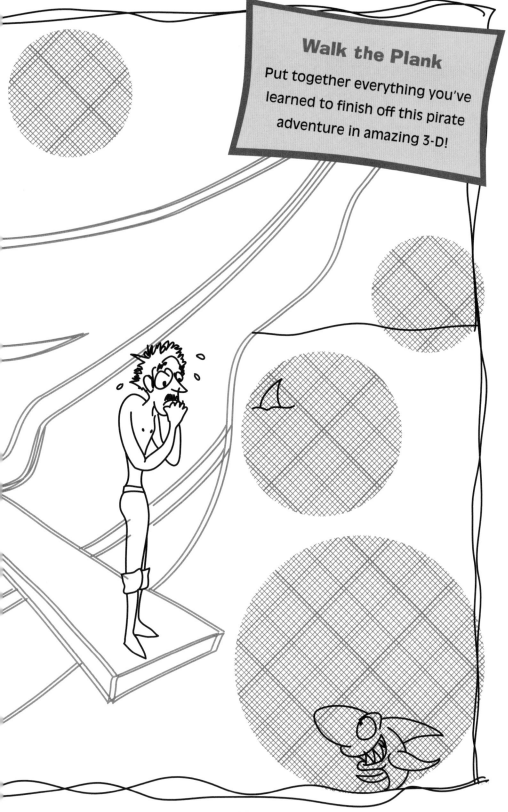

Walk the Plank

Put together everything you've learned to finish off this pirate adventure in amazing 3-D!

Create a 3-D Comic Book

Draw your own 3-D comic book story using a combination of a black pen on the 3-D grid panels, and your 3-D compass on the white panels.

3-D Doodle Sketchbook

Use these blank pages for freestyle doodling with your black pen and 3-D compass. What creative stereo scenes can you design?

About the Author

Elizabeth Encarnacion is the author of fourteen books, including *The Jimmy Buffett Concert Handbook*, *The Girls' Guide to Campfire Activities*, and *Cat's Cradle and Other Fantastic String Figures*. When she's not busy writing, Elizabeth works as a book editor and developer, volunteers with Philadelphia's Spells Writing Center, and leads a Girl Scout troop. Please visit Elizabeth's website at www.elizabethencarnacion.com.

About Cider Mill Press Book Publishers

Good ideas ripen with time. From seed to harvest, Cider Mill Press strives to bring fine reading, information, and entertainment together between the covers of its creatively crafted books. Our Cider Mill bears fruit twice a year, publishing a new crop of titles each spring and fall.

Visit us on the Web at
www.cidermillpress.com
or write to us at
12 Port Farm Road
Kennebunkport, Maine 04046

This 3-D sketchbook
belongs to

...

...